This Is the Season

BELOVED OF THE YEAR

Music and lyrics for "The Nativity Song," by Patricia Kelsey Graham,
can be found in Children's Songbook *(Salt Lake City: The Church*
of Jesus Christ of Latter-day Saints, 1989), 52–53. Used with permission.

LIBRARY OF CONGRESS CATALOGING-IN-PUBLICATION DATA

Dewey, Simon.
 This is the season beloved of the year / Simon Dewey.
 p. cm.
 ISBN 1-57008-858-6 (alk. paper)
 1. Dewey, Simon. 2. Jesus Christ—Nativity—Art. I. Title.
 ND237.D437 A4 2002

242'.335—dc21 2002009754

Printed in the United States of America 42316-6989

Inland Press, Menomonee Falls, WI

10 9 8 7 6 5 4 3 2 1

This Is the Season

Beloved of the Year

Artwork by Simon Dewey

EAGLE
GATE

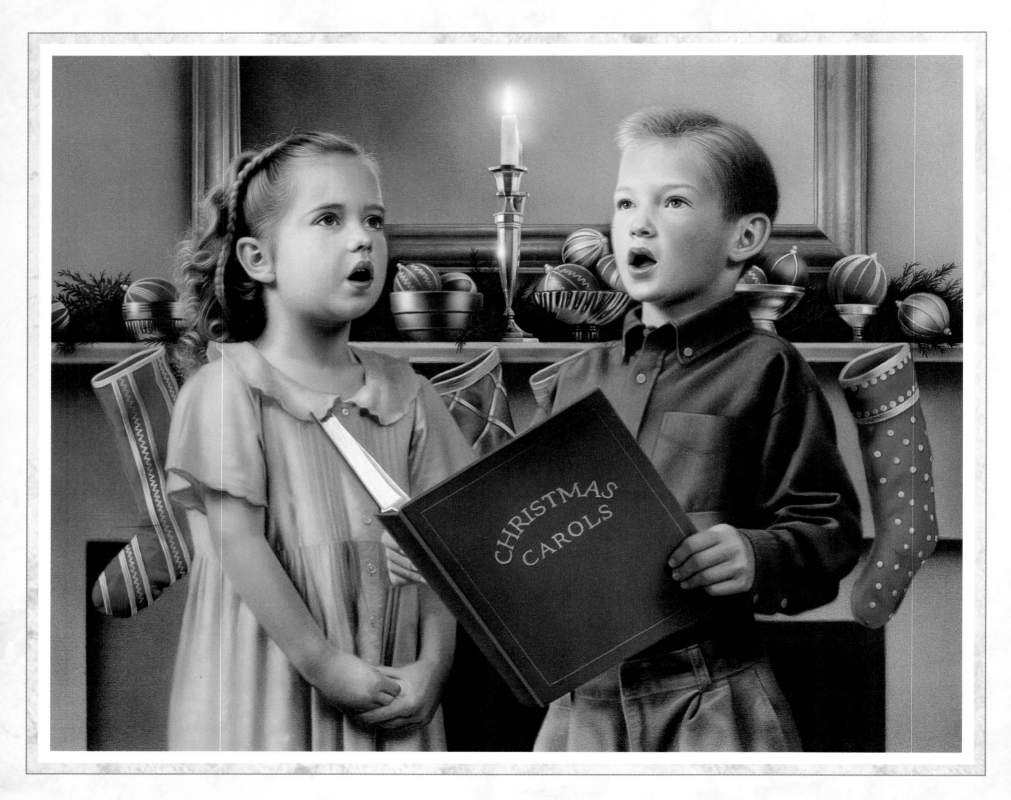

This is the season beloved of the year.
Sing a rhyme; Christmastime soon will be here.

hat a glorious and wonderful season of year this is. Our hearts change. Our attitudes change. Our way of thinking changes. There is a little more forgiveness in us. A little more of kindness. A little more of love. A little more of patience. A little more of understanding at the Christmas season of the year. What a glorious thing it is that at least once in twelve months we can become a little better than we have been during the remainder of the year. Thanks be to God for the gift of His son, and thanks be to His Son for the gift of His life. How grateful we are at this Christmas season.

—GORDON B. HINCKLEY

(Teachings of Gordon B. Hinckley [Salt Lake City: Deseret Book, 1997], 60–61)

LIFT UP YOUR HEAD AND BE OF GOOD CHEER; FOR BEHOLD, THE TIME IS AT HAND, AND ON THIS NIGHT SHALL THE SIGN BE GIVEN, AND ON THE MORROW COME I INTO THE WORLD, TO SHOW UNTO THE WORLD THAT I WILL FULFIL ALL THAT WHICH I HAVE CAUSED TO BE SPOKEN BY THE MOUTH OF MY HOLY PROPHETS.

—3 NEPHI 1:13

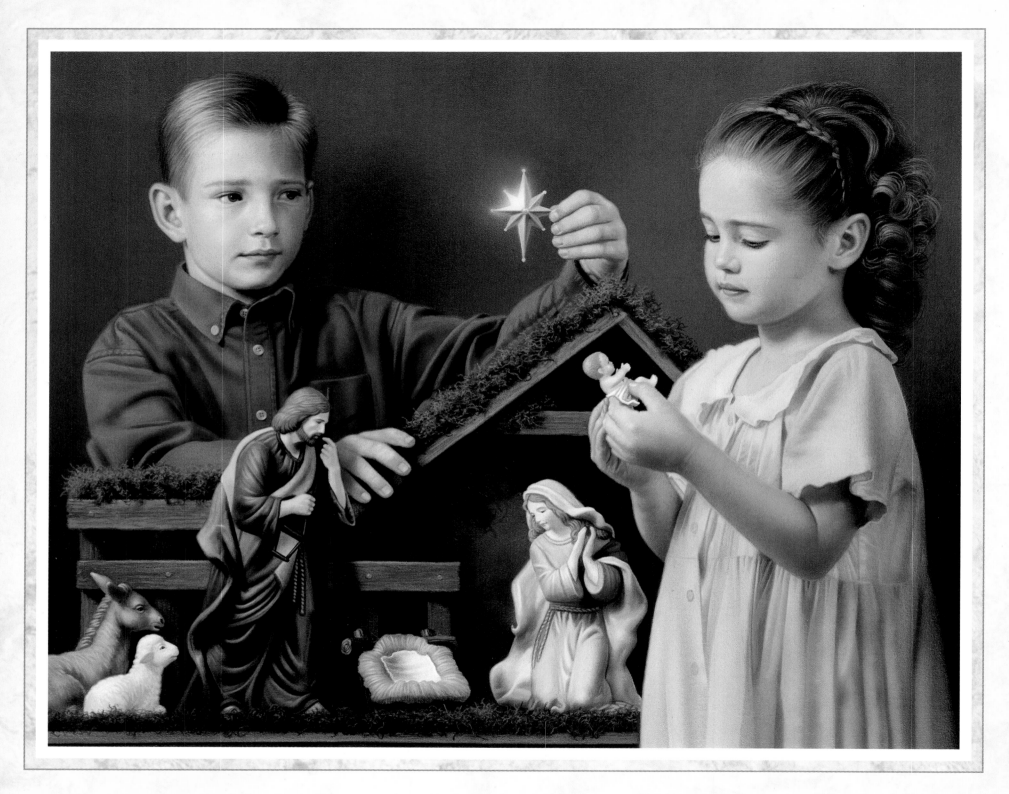

Tell the true story of Jesus' birth,
When, as a baby, he came to the earth.

n the story of the birth of Jesus we are told that there were with the angels a multitude of the heavenly host, praising God and saying: "Glory to God in the highest, and on earth, peace, good will toward men." In that announcement are implied—almost definitely stated—three guiding principles to the realization of the establishing of the Kingdom of God.

First, is an acknowledgment of the existence of Deity to whom we shall give glory and honor.

Second, is the establishment of peace through individual righteousness. Such a peace will result in the *third* principle, the brotherhood of man. . . .

. . . Brotherhood involves service and not conquest. It involves confidence in man, in your brother; not suspicion and hatred. It involves truthful dealings; not chicanery and fraud.

It is the spirit of brotherhood in the cheer of Christmas that makes it so glorious. Thank heaven for the spirit of Christmas that brings us closer to each other in expression of such brotherhood!

—DAVID O. MCKAY

(*Pathways to Happiness* [Salt Lake City: Bookcraft, 1957], 33–34)

> AND SHE SHALL BRING FORTH A SON, AND THOU SHALT CALL HIS NAME JESUS: FOR HE SHALL SAVE HIS PEOPLE FROM THEIR SINS.
>
> —MATTHEW 1:21

The new star [of Bethlehem] would have had to be placed in its precise orbit long, long before it shone so precisely!

By reflecting such careful divine design, it underscored what the Lord has said: "All things must come to pass in their time" (D&C 64:32). His planning and precision pertain not only to astrophysical orbits but to human orbits as well. This is a stunning thing for us to contemplate in all seasons! . . .

There is a personalized plan for each of us. Like the Christmas star, each of us, if faithful, has an ordained orbit, a priesthood path, as we pass through this second estate.

—NEAL A. MAXWELL

(The Christmas Scene, booklet
[Salt Lake City: Bookcraft, 1994], 2–3)

AND IT CAME TO PASS THAT THERE WAS NO DARKNESS IN ALL THAT NIGHT, BUT IT WAS AS LIGHT AS THOUGH IT WAS MID-DAY. AND IT CAME TO PASS THAT THE SUN DID RISE IN THE MORNING AGAIN, ACCORDING TO ITS PROPER ORDER; AND THEY KNEW THAT IT WAS THE DAY THAT THE LORD SHOULD BE BORN, BECAUSE OF THE SIGN WHICH HAD BEEN GIVEN. AND IT HAD COME TO PASS, YEA, ALL THINGS, EVERY WHIT, ACCORDING TO THE WORDS OF THE PROPHETS. AND IT CAME TO PASS ALSO THAT A NEW STAR DID APPEAR, ACCORDING TO THE WORD.

—3 NEPHI 1:19–21

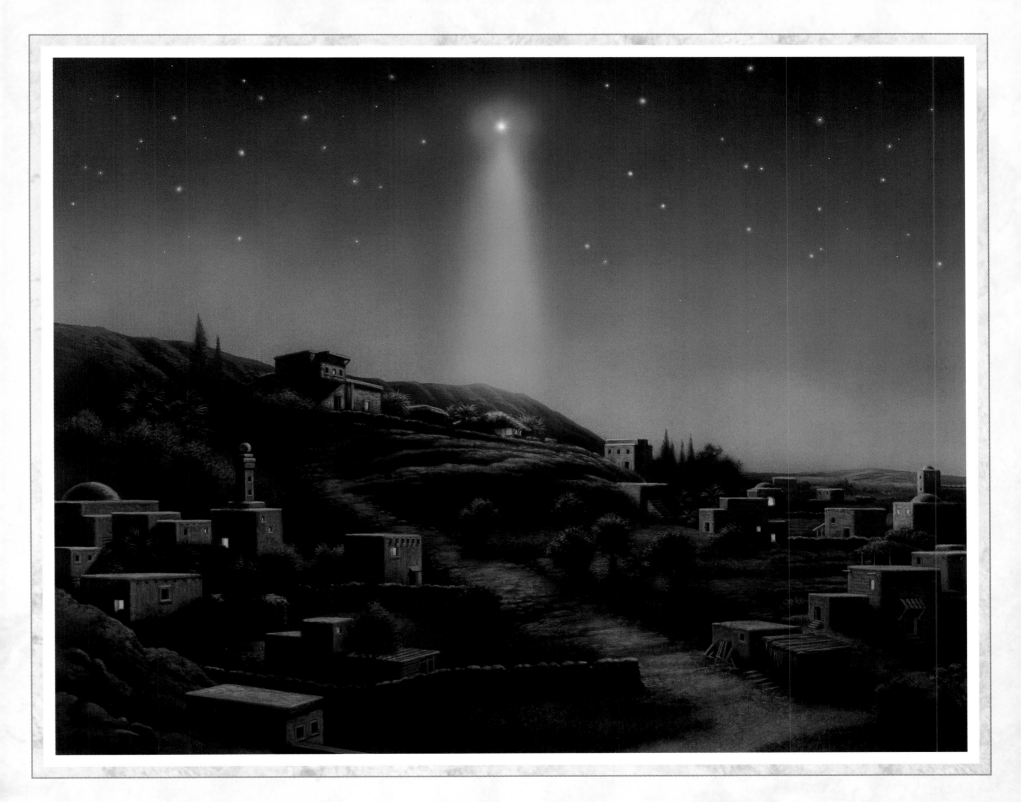

This is the new star, shining so bright,
Lighting the world on that first Christmas night.

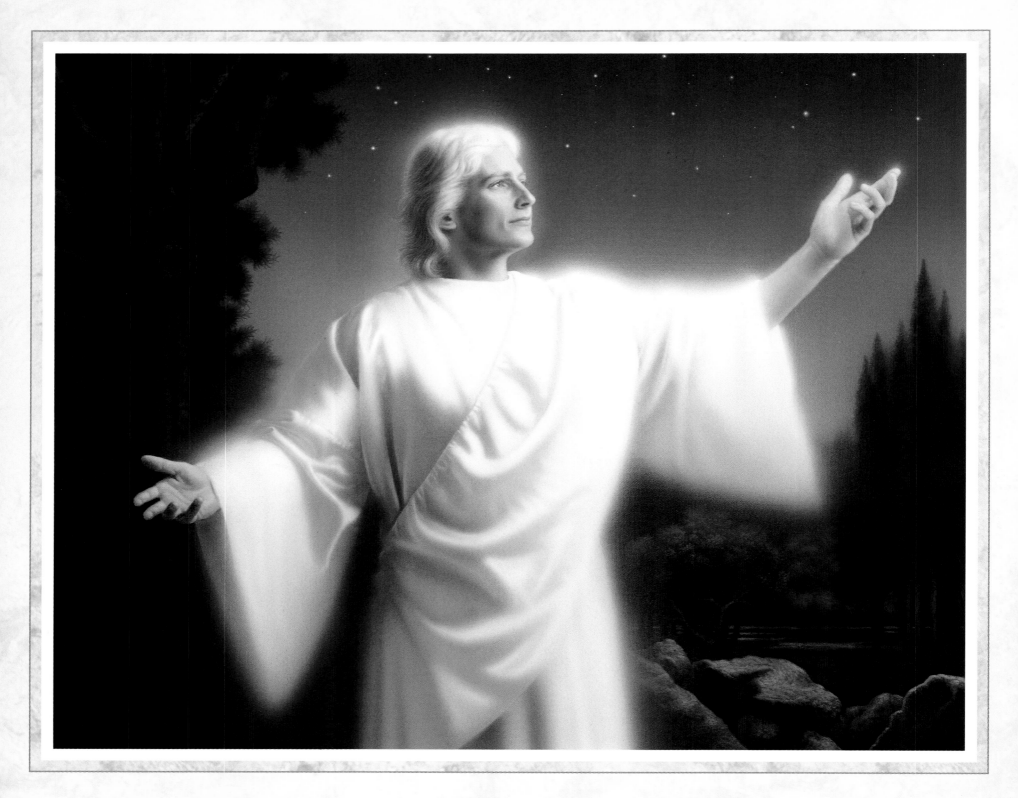

This is the angel proclaiming the birth,
Singing "Hosanna!" and "Peace on the earth!"

eralded centuries before his birth as the "Prince of Peace" (Isaiah 9:6), heavenly angels announced his coming, saying: "Glory to God in the highest, and on earth peace, good will toward men." (Luke 2:14.)

Modern man sometimes vainly thinks that Jesus' mission was to wipe out war; and scoffers have cried that since war still curses the earth, Christ's mission has failed and Christianity is a blight.

Yet Christ himself sent forth his Twelve, saying: "Think not that I am come to send peace on earth: I came not to send peace, but a sword." (Matthew 10:34.)

Christ did proclaim a peace—the peace of everlasting righteousness, which is the eternal and mortal enemy of sin. Between righteousness and sin, in whatever form, there can only be unceasing war, whether in one man, among the people, or between nations in armed conflict. This war is the sword of Christ; whatever its form this war cannot end until sin is crushed and Christ brings all flesh under his dominion.

—J. Reuben Clark, Jr.

(in Conference Report, April 1939, 104)

> And the angel said unto them, Fear not: for, behold, I bring you good tidings of great joy, which shall be to all people. For unto you is born this day in the city of David a Saviour, which is Christ the Lord. . . . And suddenly there was with the angel a multitude of the heavenly host praising God, and saying, Glory to God in the highest, and on earth peace, good will toward men.
>
> —Luke 2:10–11, 13–14

was a student at BYU just finishing my first year of graduate work when our first child, a son, was born. We were very poor, though not so poor as Joseph and Mary. . . .

Nevertheless, when I realized that our own night of nights was coming, I believe I would have done any honorable thing in this world, and mortgaged any future I had, to make sure my wife had the clean sheets, the sterile utensils, the attentive nurses, and the skilled doctors who brought forth our firstborn son. . . .

I compare those feelings . . . with what Joseph must have felt as he moved through the streets of a city not his own, with not a friend or kinsman in sight, nor anyone willing to extend a helping hand. In these very last and most painful hours of her "confinement,"

Mary had ridden or walked approximately 100 miles from Nazareth in Galilee to Bethlehem in Judea. Surely Joseph must have wept at her silent courage. Now, alone and unnoticed, they had to descend from human company to a stable, a grotto full of animals, there to bring forth the Son of God.

I wonder what emotions Joseph might have had as he cleared away the dung and debris. I wonder if he felt the sting of tears as he hurriedly tried to find the cleanest straw and hold the animals back. I wonder if he wondered: ". . . Is this a place fit for a king? Should the mother of the Son of God be asked to enter the valley of the shadow of death in such a foul and unfamiliar place as this?"

. . . But I am certain Joseph did not mutter and Mary did not wail. They knew a great deal and did the best they could.

—JEFFREY R. HOLLAND

("'Maybe Christmas Doesn't Come from a Store,'" *Ensign*, December 1977, 64–65)

> AND SHE BROUGHT FORTH HER FIRSTBORN SON,
>
> AND WRAPPED HIM IN SWADDLING CLOTHES,
>
> AND LAID HIM IN A MANGER; BECAUSE THERE
>
> WAS NO ROOM FOR THEM IN THE INN.
>
> —LUKE 2:7

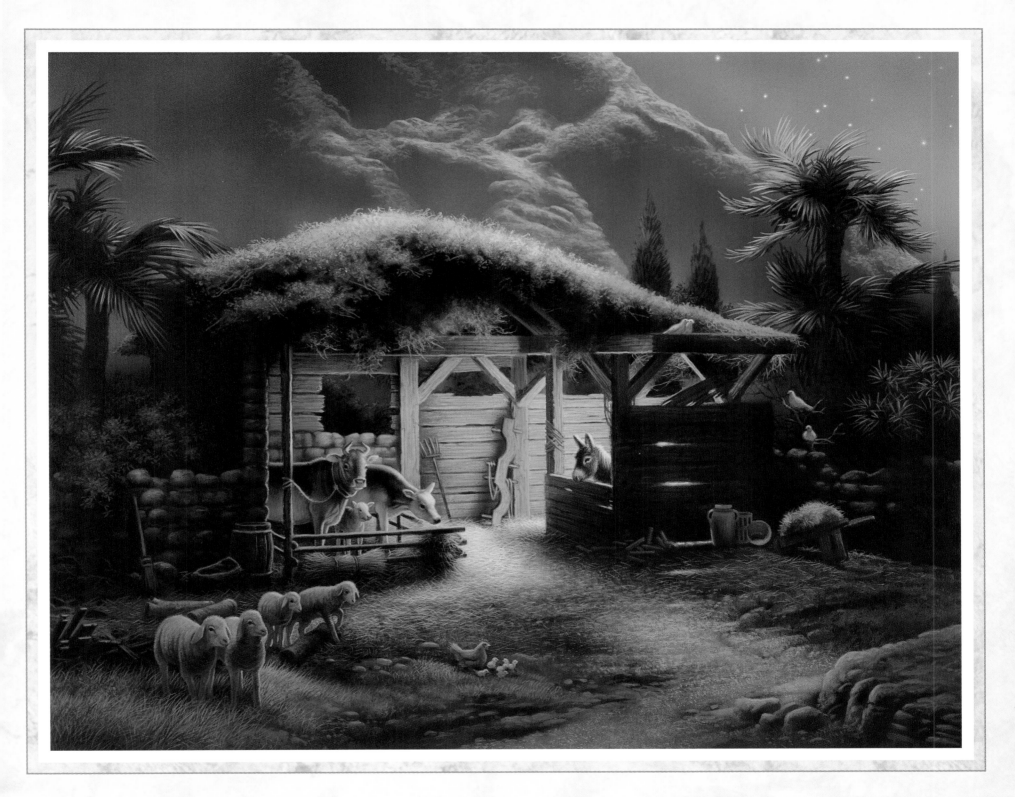

This is the stable, shelter so bare;
Cattle and oxen first welcomed him there.

The throngs must have been incredible, the facilities throughout the city taxed beyond belief. And with Bethlehem only six miles south of Jerusalem, no wonder there was no room at the inn. . . .

. . . The inns of the Holy Land were typically large, fortress-like buildings, built around a spacious open square. Called *khans* or *caravanserai,* they provided stopping places for the caravans of the ancient world.

Just as modern hotels and motels must provide parking for automobiles, so did a *caravanserai* have to provide a place where the donkeys, camels, and other animals could be safely cared for. Inside the *khan,* . . . all the "rooms" faced the courtyard. They were typically arched, open antechambers facing out onto the square. Here the traveler could build a small fire or sleep within clear view of his animals and goods. . . .

Even if there had been room at the inn, a *caravanserai* was hardly the ideal place for a woman in labor. Perhaps the innkeeper, moved with compassion at Mary's plight and knowing of her need and desire for privacy, offered them his stable. Perhaps Joseph found the place on his own. The scriptures do not say.

—GERALD N. LUND

(Jesus Christ, Key to the Plan of Salvation [Salt Lake City: Deseret Book, 1991], 14–15)

AND THIS SHALL BE A SIGN UNTO YOU;
YE SHALL FIND THE BABE WRAPPED IN
SWADDLING CLOTHES, LYING IN A MANGER.

—LUKE 2:12

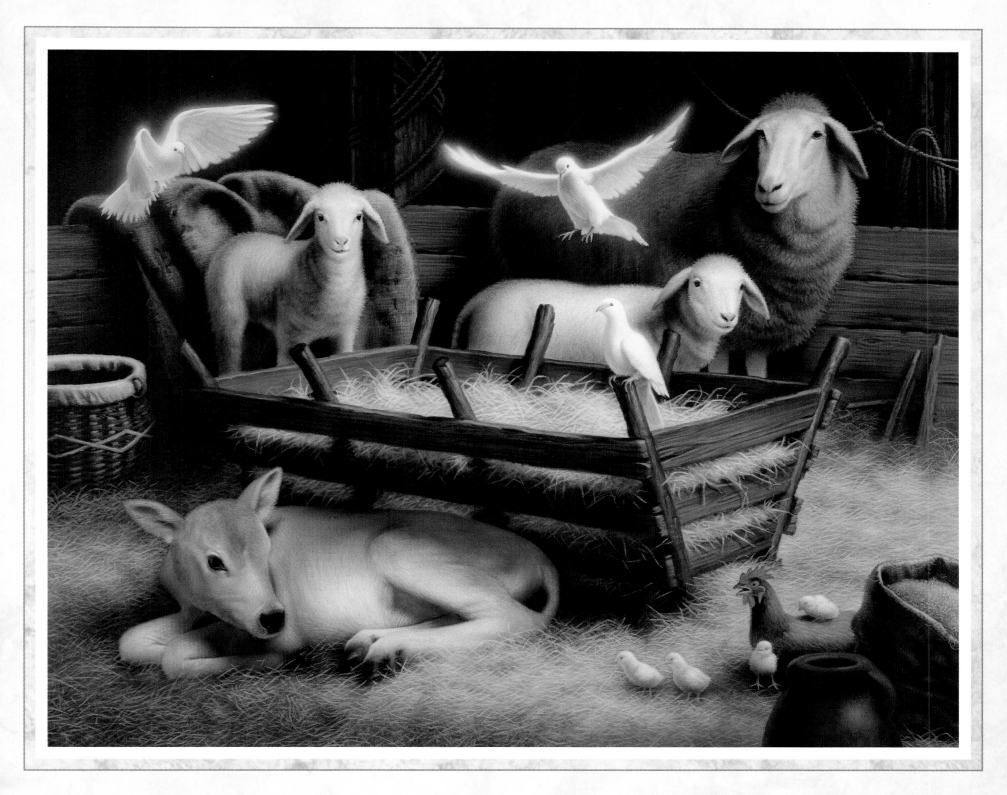

This is the manger, sweet hay for a bed,
Waiting for Jesus to cradle his head.

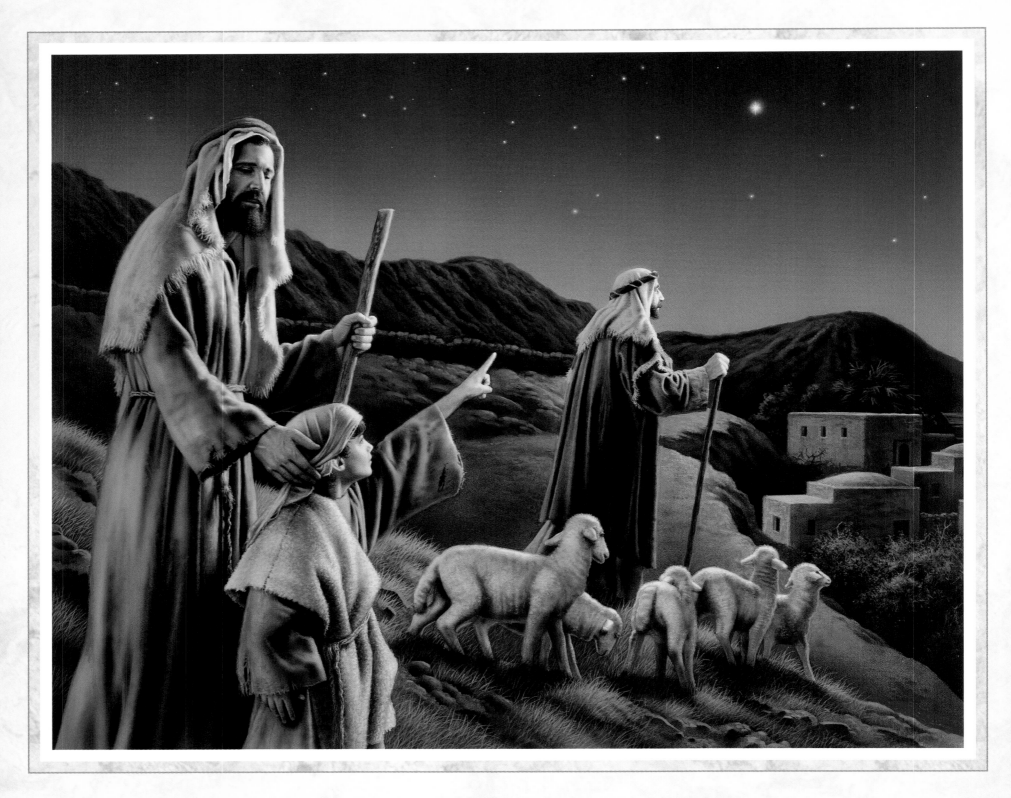

These are the shepherds, humble and mild,
Hast'ning to worship the heavenly child.

In the fields of Bethlehem, not far from Jerusalem and the Temple of Jehovah, there were shepherds watching their flocks by night. These were not ordinary shepherds nor ordinary flocks. The sheep there being herded—nay, not herded, but watched over, cared for with love and devotion—were destined for sacrifice on the great altar in the Lord's House, in similitude of the eternal sacrifice of Him who that wondrous night lay in a stable, perhaps among sheep of lesser destiny. And the shepherds—for whom the veil was then rent: surely they were in spiritual stature like Simeon and Anna and Zacharias and Elisabeth and Joseph and the growing group of believing souls who were coming to know, by revelation, that the Lord's Christ was now on earth.

—BRUCE R. MCCONKIE

(*The Mortal Messiah: From Bethlehem to Calvary,* 4 vols. [Salt Lake City: Deseret Book, 1979–81], 1:347)

AND IT CAME TO PASS, AS THE ANGELS WERE GONE AWAY FROM THEM INTO HEAVEN, THE SHEPHERDS SAID ONE TO ANOTHER, LET US NOW GO EVEN UNTO BETHLEHEM, AND SEE THIS THING WHICH IS COME TO PASS, WHICH THE LORD HATH MADE KNOWN UNTO US. AND THEY CAME WITH HASTE, AND FOUND MARY, AND JOSEPH, AND THE BABE LYING IN A MANGER.

—LUKE 2:15–16

hristmastime is a glorious time of happy friendliness and unselfish sacrifice

We set up the evergreen tree with its gleaming, brightly colored lights; we hang wreaths and bells; and we light candles—all to remind us of that wondrous gift, the coming of our Lord into the world of mortality. . . .

Like the wise men who opened their treasury and presented to Jesus gifts of gold and frankincense and myrrh, we present to our loved ones things to eat and wear and enjoy.

Though we make an effort to follow the pattern of gift giving, sometimes our program becomes an exchange—gift given for gift expected. Never did the Savior give in expectation. I know of no case in his life in which there was an exchange. He was always the giver, seldom the recipient. . . . His gifts were of such a nature that the recipient could hardly exchange or return the value. His gifts were rare ones: eyes to the blind, ears to the deaf, and legs to the lame; cleanliness to the unclean, wholeness to the infirm, and breath to the lifeless. His gifts were opportunity to the down-trodden, freedom to the oppressed, light in the darkness, forgiveness to the repentant, hope to the despairing. . . . The wise men brought him gold and frankincense. He gave them and all their fellow mortals resurrection, salvation, and eternal life.

—SPENCER W. KIMBALL

(The Teachings of Spencer W. Kimball, ed. Edward L. Kimball [Salt Lake City: Bookcraft, 1982], 246)

WHEN THEY HAD HEARD THE KING, THEY DEPARTED; AND, LO, THE STAR, WHICH THEY SAW IN THE EAST, WENT BEFORE THEM, TILL IT CAME AND STOOD OVER WHERE THE YOUNG CHILD WAS. WHEN THEY SAW THE STAR, THEY REJOICED WITH EXCEEDING GREAT JOY. AND WHEN THEY WERE COME INTO THE HOUSE, THEY SAW THE YOUNG CHILD WITH MARY HIS MOTHER, AND FELL DOWN, AND WORSHIPPED HIM: AND WHEN THEY HAD OPENED THEIR TREASURES, THEY PRESENTED UNTO HIM GIFTS; GOLD, AND FRANKINCENSE, AND MYRRH.

—MATTHEW 2:9–11

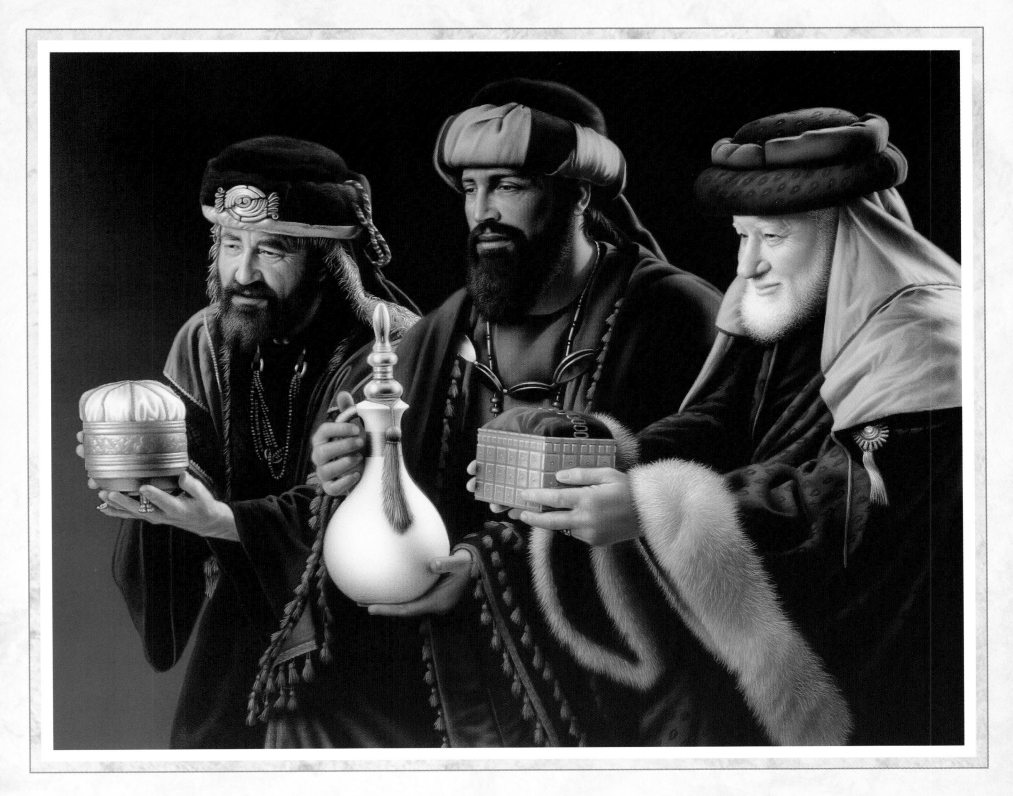

These are the wise men who followed the star,
Frankincense, gold, and myrrh brought from afar.

s there is only one Christ, so there is only one Mary. And as the Father chose the most noble and righteous of all his spirit sons to come into mortality as his Only Begotten in the flesh, so we may confidently conclude that he selected the most worthy and spiritually talented of all his spirit daughters to be the mortal mother of his Eternal Son.

—BRUCE R. McCONKIE

(*Doctrinal New Testament Commentary*, 3 vols. [Salt Lake City: Bookcraft, 1965–73], 1: 85)

AND BEHOLD, HE SHALL BE BORN OF MARY, AT JERUSALEM WHICH IS THE LAND OF OUR FOREFATHERS, SHE BEING A VIRGIN, A PRECIOUS AND CHOSEN VESSEL, WHO SHALL BE OVERSHADOWED AND CONCEIVE BY THE POWER OF THE HOLY GHOST, AND BRING FORTH A SON, YEA, EVEN THE SON OF GOD.

—ALMA 7:10

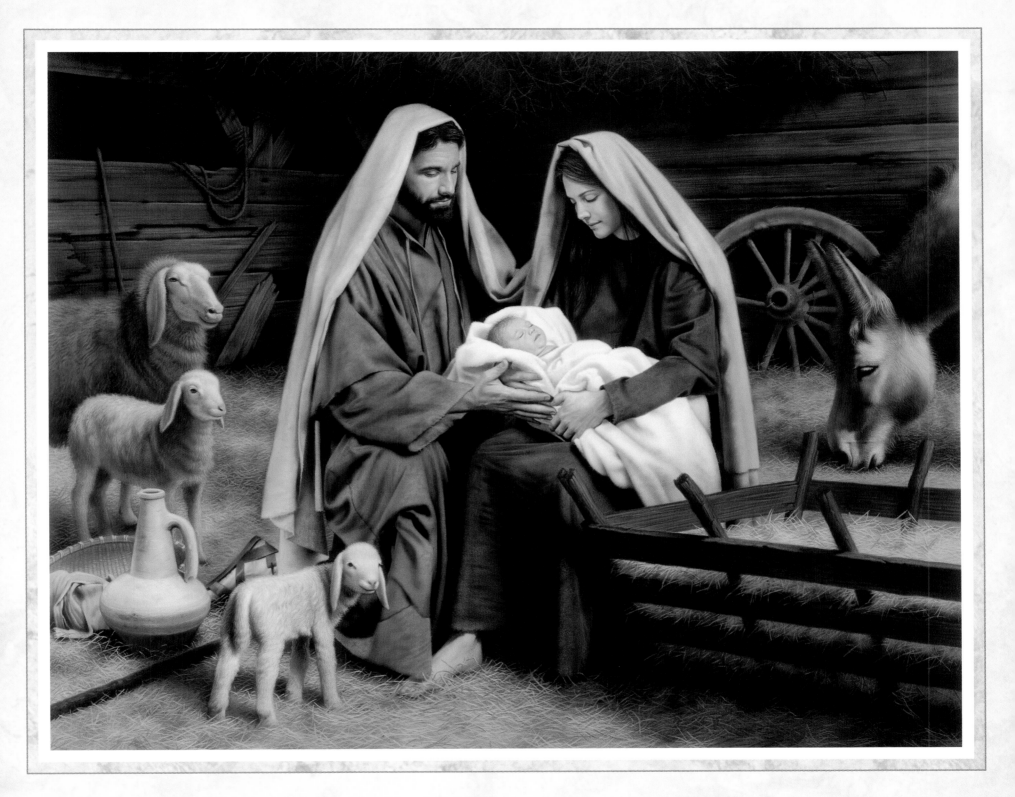

See the sweet mother, Mary so fair,
Joseph, who guided the donkey with care.

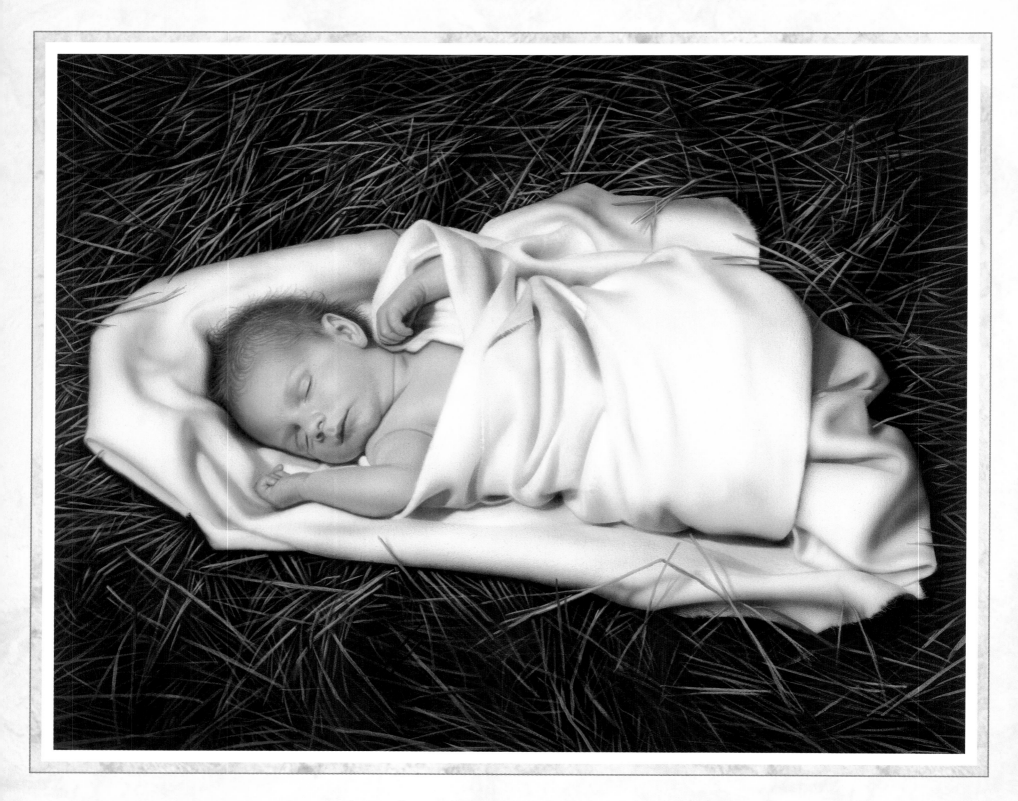

See the dear baby of Bethlehem,
Little Lord Jesus, the Savior of men.

Perhaps one of the greatest things about this wonderful Christmas season we celebrate is that it increases our sensitivity to things spiritual, to things of God. It causes us to contemplate our relationship with our Father and the degree of devotion we have for God.

It prompts us to be more tolerant and giving, more conscious of others, more generous and genuine, more filled with hope and charity and love—all Christlike attributes. No wonder the spirit of Christmas is such that it touches the hearts of people the world over. Because for at least a time, increased attention and devotion is turned toward our Lord and Savior, Jesus Christ. . . .

. . . Let us commit to give a most meaningful gift to the Lord. Let us give Him our lives, our sacrifices. Those who do so will discover that He can make a lot more out of their lives than they can. Whoever will lose his life in the service of God will find eternal life.

Without Christ there would be no Christmas, and without Christ there can be no fulness of joy. It is my testimony that the Babe of Bethlehem, Jesus the Christ, is the one perfect guide, the one perfect example. Only by emulating Him and adhering to His eternal truth can we realize peace on earth and good will toward all. There is no other way. He is the Way, the Truth, and the Light.

—EZRA TAFT BENSON

(Ezra Taft Benson Remembers the Joy of Christmas [Salt Lake City: Deseret Book, 1988], 12–13)

> FOR UNTO US A CHILD IS BORN, UNTO US A SON IS GIVEN: AND THE GOVERNMENT SHALL BE UPON HIS SHOULDER: AND HIS NAME SHALL BE CALLED WONDERFUL, COUNSELLOR, THE MIGHTY GOD, THE EVERLASTING FATHER, THE PRINCE OF PEACE.
>
> —ISAIAH 9:6

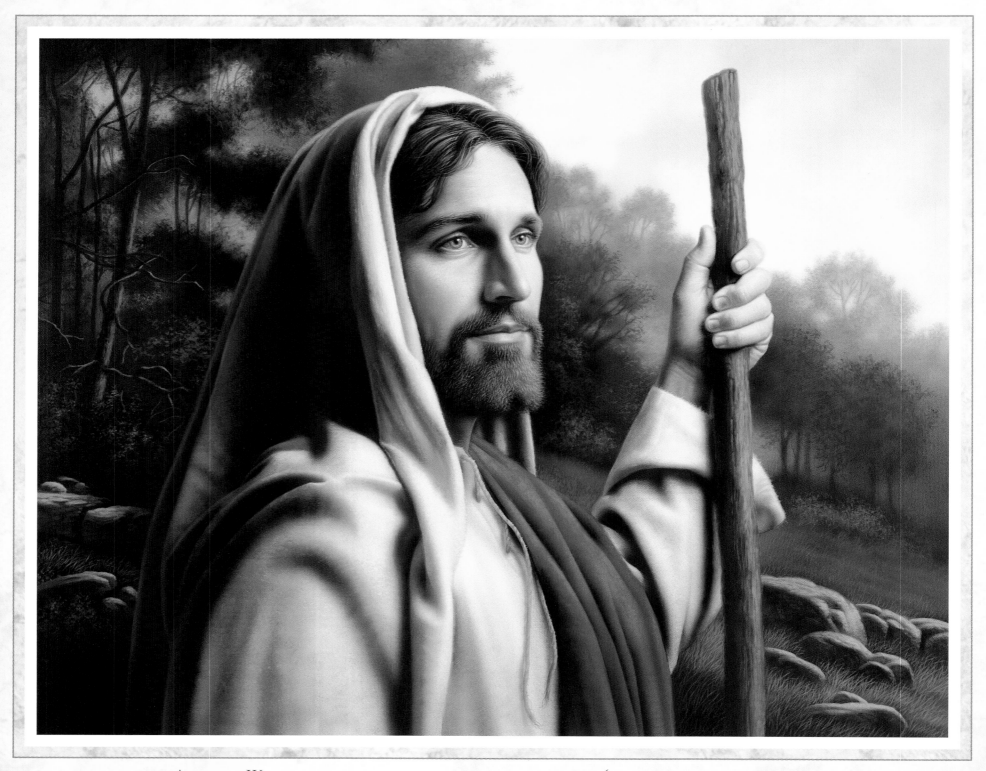

AND THE WORD WAS MADE FLESH, AND DWELT AMONG US, (AND WE BEHELD HIS GLORY,
THE GLORY AS OF THE ONLY BEGOTTEN OF THE FATHER,) FULL OF GRACE AND TRUTH.

—John 1:14